To:

Mo to share the "Wonders" with your granddaughters

From:

Annie & Matt

2019

Lightning bugs among wild alfalfa on the Kansas prairie

little book of Wonders

Celebrating the Gifts
of the Natural World

Nadia Drake

□ NATIONAL GEOGRAPHIC

Washington, D.C.

Since 1888, the National Geographic Society has funded more than 12,000 research, exploration, and preservation projects around the world. National Geographic Partners distributes a portion of the funds it receives from your purchase to National Geographic Society to support programs including the conservation of animals and their habitats.

National Geographic Partners
1145 17th Street NW
Washington, DC 20036-4688 USA

Become a member of National Geographic and activate your benefits today at natgeo.com/jointoday.

For information about special discounts for bulk purchases, please contact National Geographic Books Special Sales: specialsales@natgeo.com

For rights or permissions inquiries, please contact National Geographic Books Subsidiary Rights: bookrights@natgeo.com

ISBN: 978-1-4262-1689-3

Interior design by Nicole Miller

Printed in Hong Kong

16/THK/1

For planet Earth

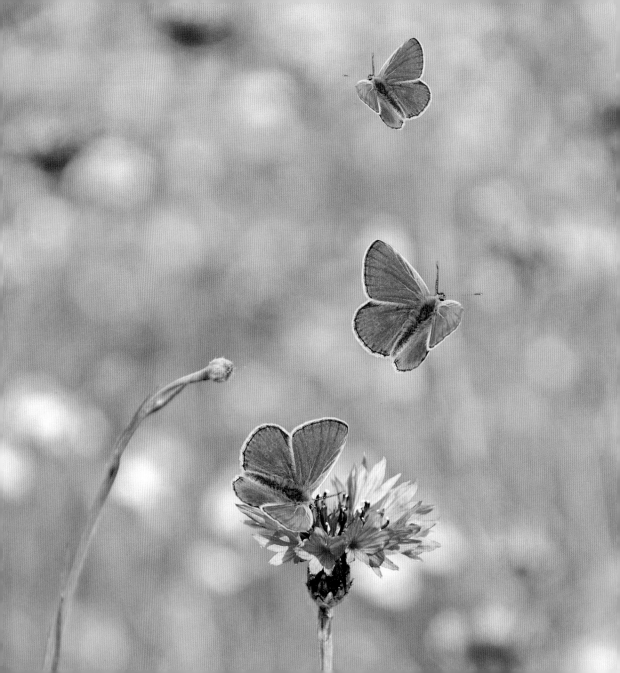

Introduction

The natural world is rich with wonders. Astounding geological

formations and weird chemistries form the substance of this planet

we call home—a round, watery chunk of rock that's hurtling through a sea

of stars. Some of Earth's wonders are easy to see: All you have to do is gaze

skyward or awake to freshly fallen snow. Others are a little more clandestine,

hiding in mathematical patterns or clever adaptations. I still remember how,

as a kid, I would watch squishy caterpillars tuck themselves into sacs of silk,

destined to shed their tube-shaped existence and take to the sky ten days

later on shimmering iridescent wings. In this book, I've collected a medley

of Earth's most astonishing wonders to illuminate the natural

masterpiece that is our planet.

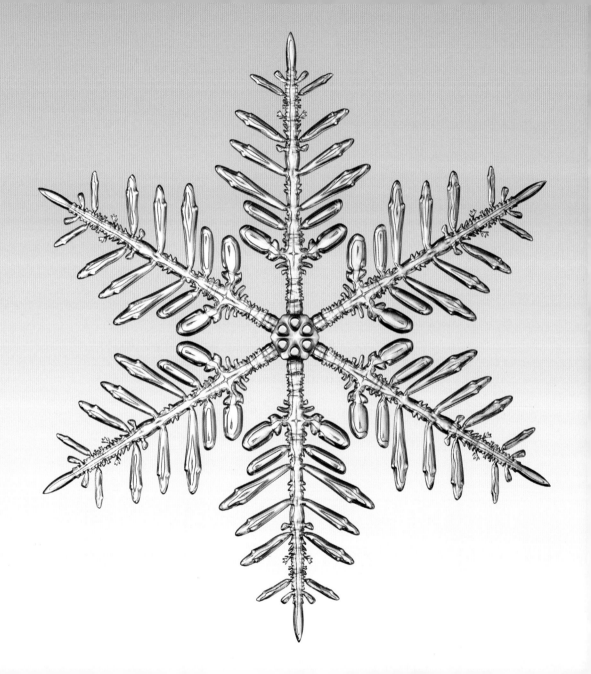

A snowflake can take as long as two hours to fall from a cloud to the ground. Single flakes are not white but translucent like glass.

Most snowflakes grow in irregular shapes, but rare beauties are perfectly symmetrical.

The sound of waves crashing comes mostly from air bubbles. Each exploding bubble has its own signature note.

The largest bubbles form as ocean surf curves in on itself.

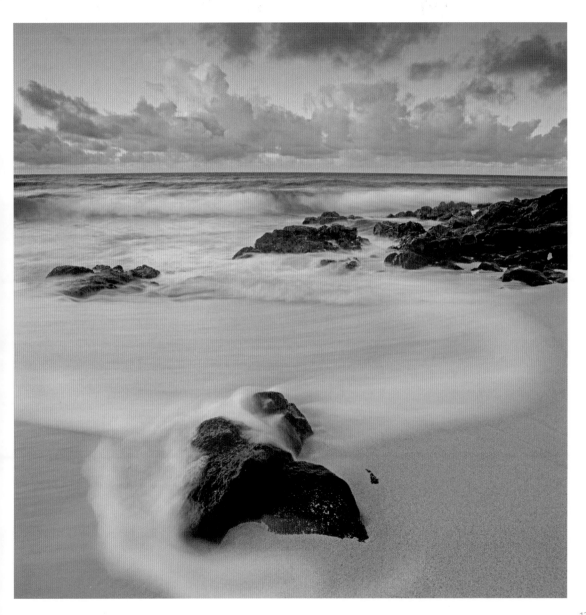

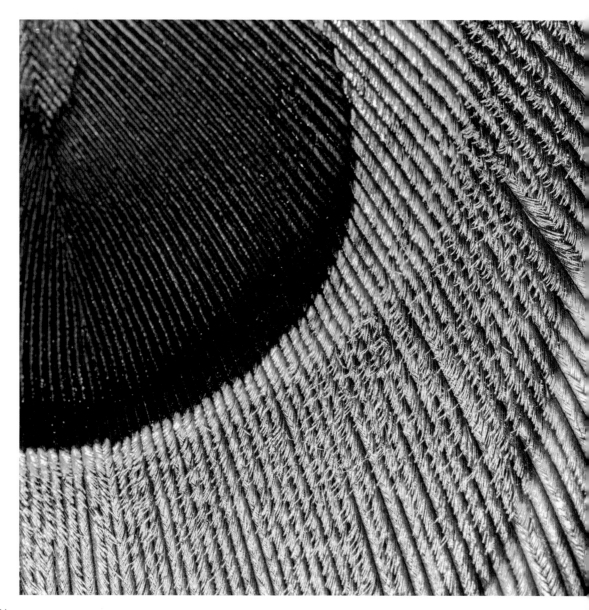

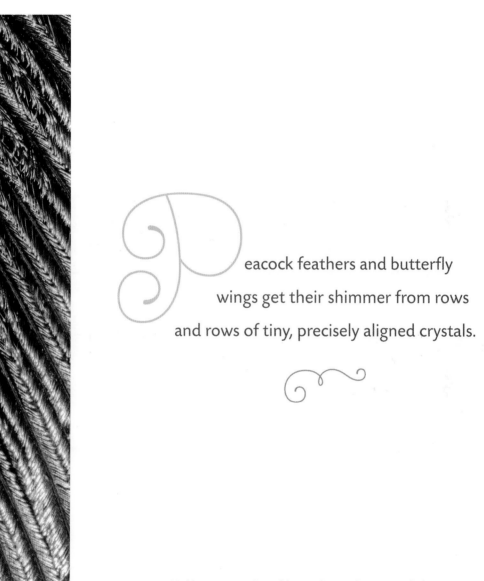

*P*eacock feathers and butterfly wings get their shimmer from rows and rows of tiny, precisely aligned crystals.

Unlike pigment-based hues, these colors never fade.

Forests of alien-looking trees sprinkle the upper slopes of Mount Kilimanjaro. Resembling a cross between a pineapple and cactus, these giant senecios are found on only a few mountains in East Africa.

Genetic work has revealed that Kilimanjaro's senecios took root first, then spread their seeds to neighboring peaks such as Mount Kenya and Mount Meru, where they evolved into different species.

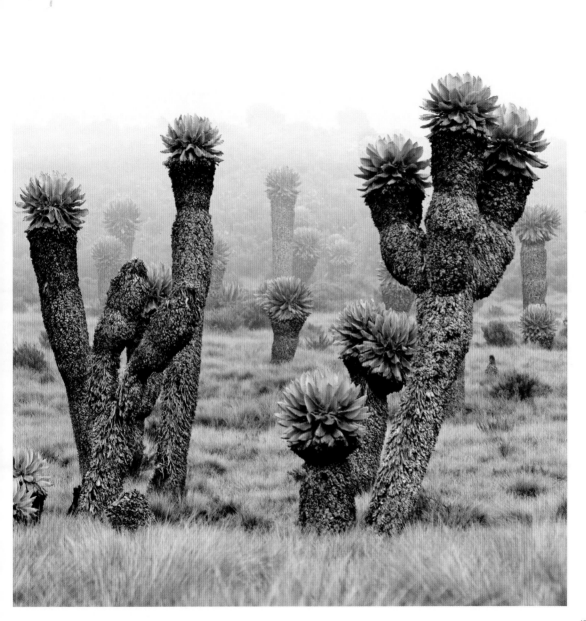

Belize's Great Blue Hole looks like an entrance to the abyss, but the sinkhole—which flooded when sea levels rose after the last ice age—is just a bit more than 400 feet (122 m) deep.

Similar structures on land, which are commonly found on the Yucatán Peninsula, are called cenotes.

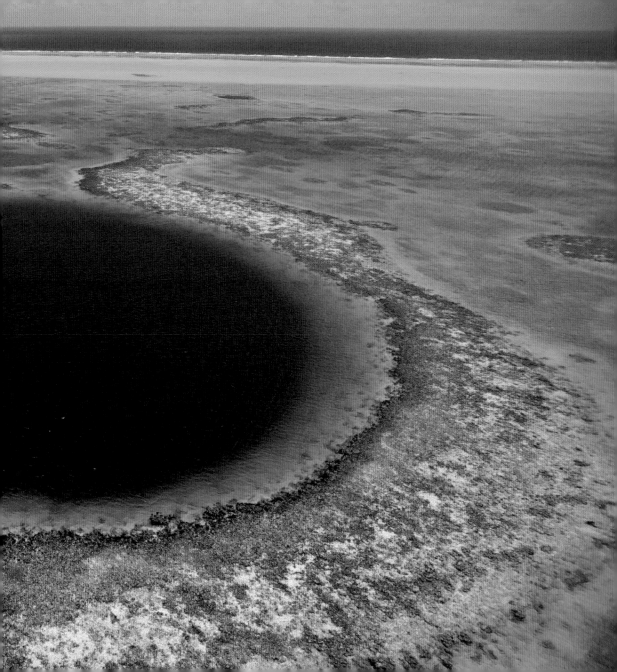

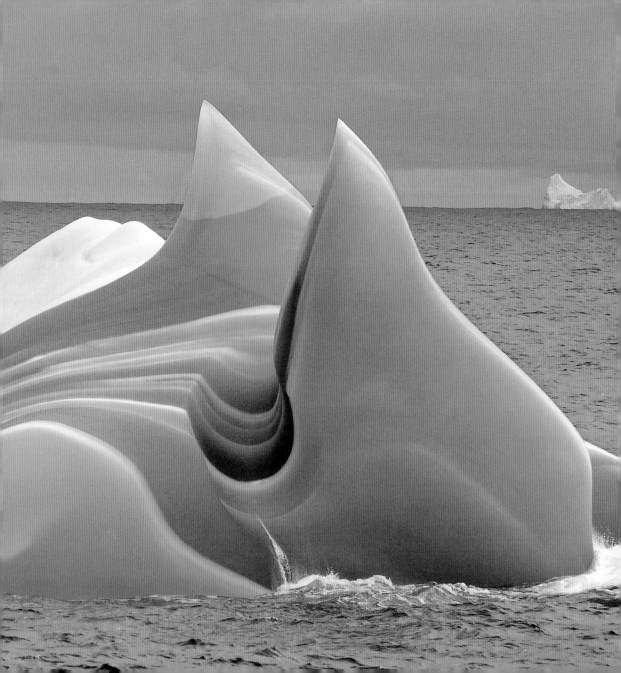

Rare, emerald-colored icebergs are actually capsized chunks of ice. When the bergs tip over, their formerly submerged bottoms are exposed, revealing frozen seawater colored by algae.

The green color is produced by the mixing of yellowish algae with blue ice.

ecently, a lost rain forest complete with a rushing river, waterfalls, and langur monkeys was discovered in the subterranean depths of Son Doong cave in Vietnam.

The cave's largest chamber could fit a Boeing 747 airplane, but its jungle-cloaked entrance prevented it from being discovered until 1991. The first caving expedition did not enter until 2009.

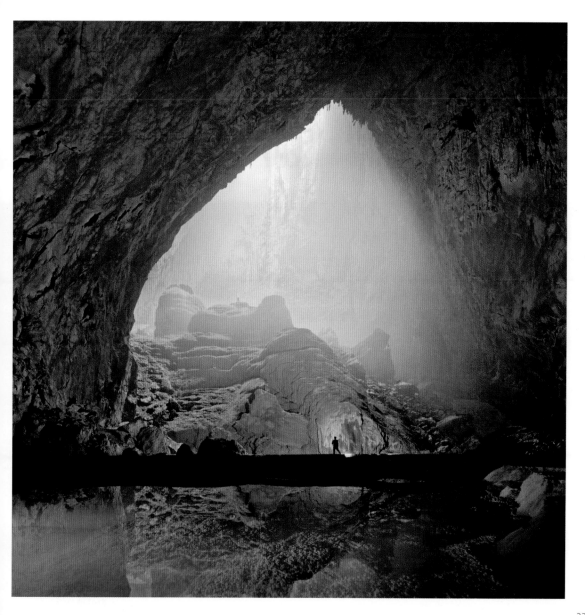

Stronger than Steel

Spider silk is one of the toughest substances around: By weight, it's five times stronger than steel and much more flexible. But not every spider makes the same kind of silk. There are at least a half dozen varieties, some fluffier, stickier, stretchier, or stronger than others. The strongest naturally occurring spider silk is capable of snaring hummingbirds, snakes, and rats—and scientists have even calculated that, yes, it could stop a moving train. The largest webs are woven by an orb-weaving spider that wasn't discovered until 2009. Known as Darwin's bark spider, this master engineer creates webs that sometimes span entire rivers.

Spider silk can vary in color, too, with some spiders producing beautiful, golden threads.

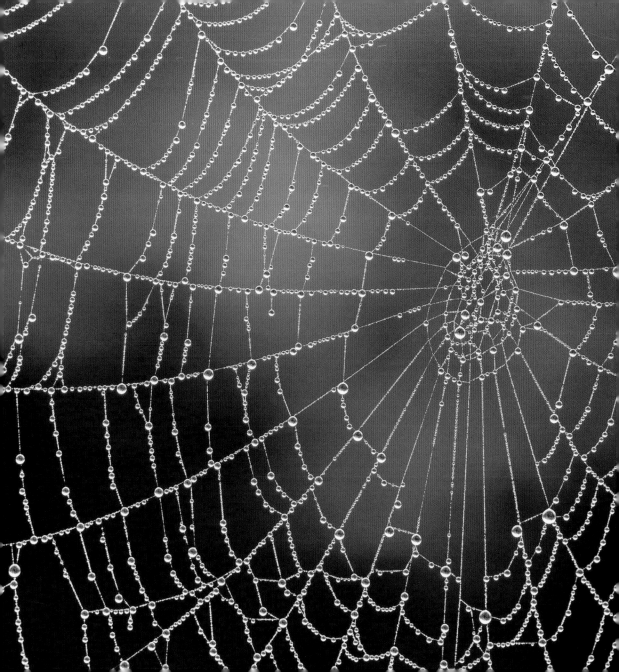

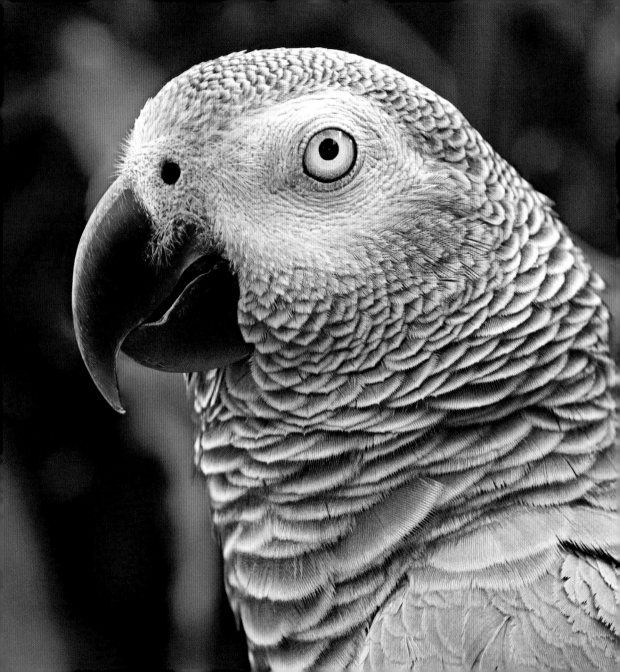

African gray parrots are intelligent, cheeky birds, capable of mimicking human speech and cracking one-liners. Their vocabularies often comprise more than 100 words.

African grays can live for 40 to 50 years.

The world's tallest uninterrupted waterfall hides in a remote Venezuelan jungle. Native tribes refer to the falls as Kerepakupai Merú, which means "waterfall of the deepest place."

Also known as Angel Falls, the waterfall dives more than 3,200 feet (975 m) into a forest filled with monkeys and poison dart frogs.

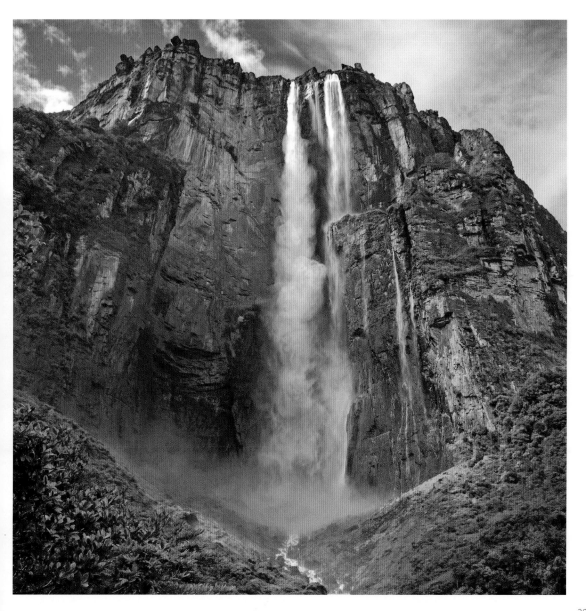

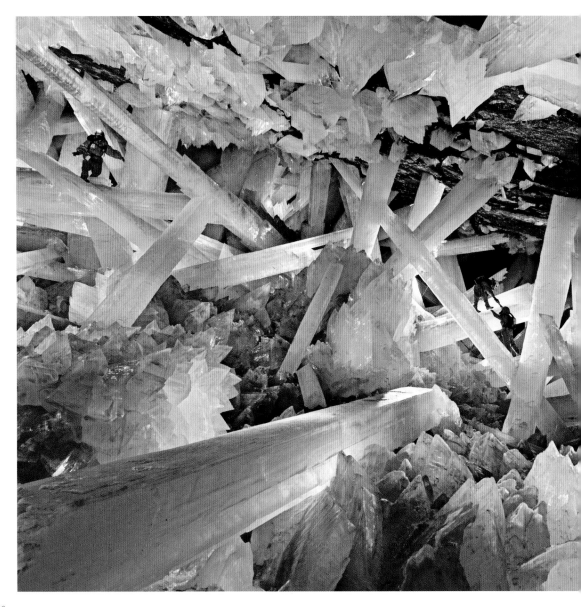

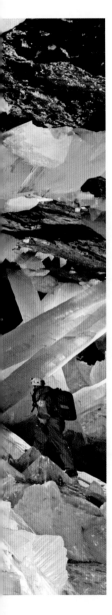

In Mexico's Cave of Crystals, buried 1,000 feet (300 m) underground, beams of gypsum can be more than 30 feet (9 m) long.

The cave was accidentally discovered in 2000, when silver miners broke through its wall.

olar bears aren't actually white. Instead, layers and layers of translucent fur scatter light of all wavelengths, making the bears appear snow-white to our eyes.

Polar bear hairs are hollow tubes, rather than thick cables, and the bears' skin is black.

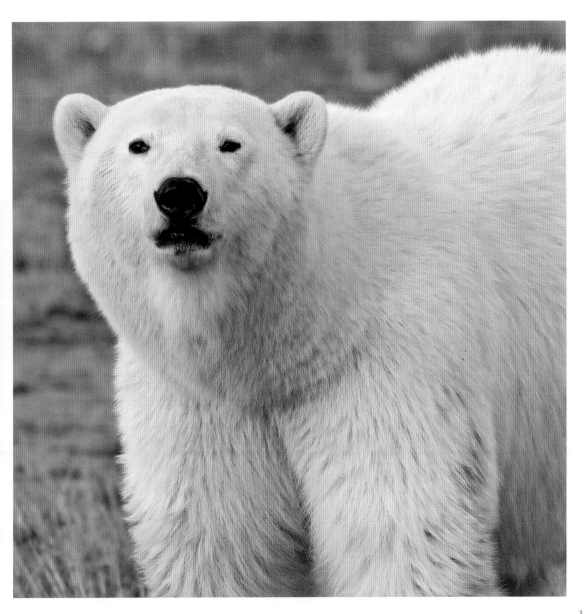

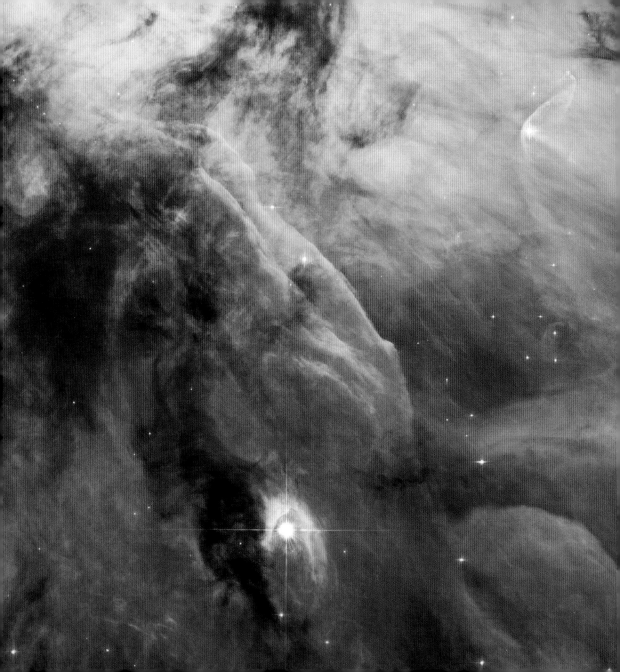

\mathcal{E}very year, 40,000 tons (36,300 mt) of cosmic dust rains down onto our planet, mostly as microscopic debris. Everything we are and everything on Earth originated from stardust.

❧

Some cosmic dust is shed by comets and asteroids, but the rest is left over from the early ages of our solar system.

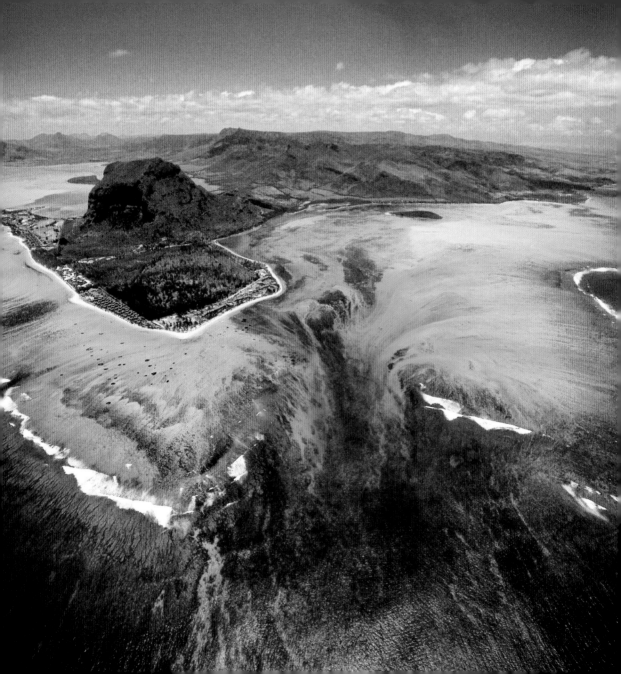

A giant, undersea waterfall appears to be looming off the coast of Mauritius. But the plunging abyss is an optical illusion: Sand driven by ocean currents creates the ghostly pattern.

About 550 miles (885 km) east of Madagascar, the sediment-produced illusion is especially spectacular when viewed from above.

Darwin's foresight

A star-shaped orchid from Madagascar caught the attention of British naturalist Charles Darwin in 1862. Called *Angraecum sesquipedale*, the flower has a bizarre, foot-long nectary. To explain the presence of that peculiar feature, Darwin predicted the existence of a moth with a foot-long tongue capable of sipping from the nectary's depths and pollinating the flower. His prediction ignited a quest to find just such a moth. Four decades later, researchers discovered a nocturnal, gigantic Madagascan sphinx moth with a foot-long tongue—precisely the creature Darwin predicted—but it wasn't until the 1990s that scientists caught the moth and orchid in action.

A moth's tongue is actually a hollow tube called a proboscis, used as a straw to sip nectar.

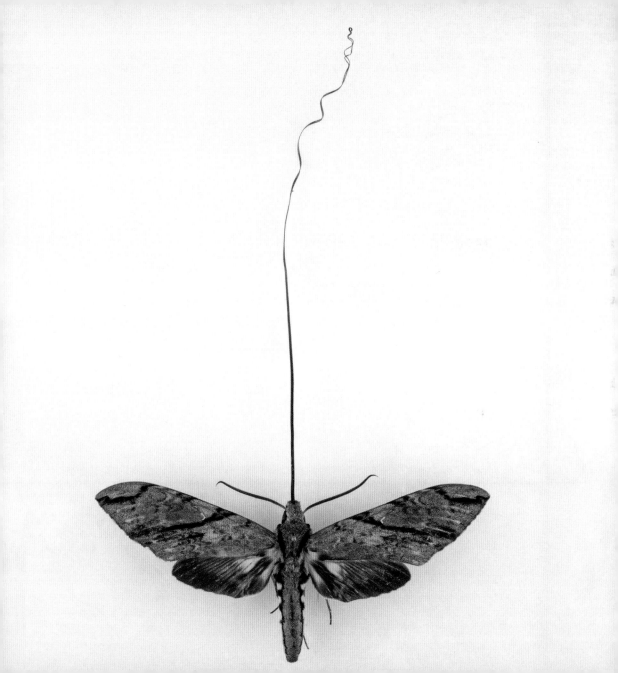

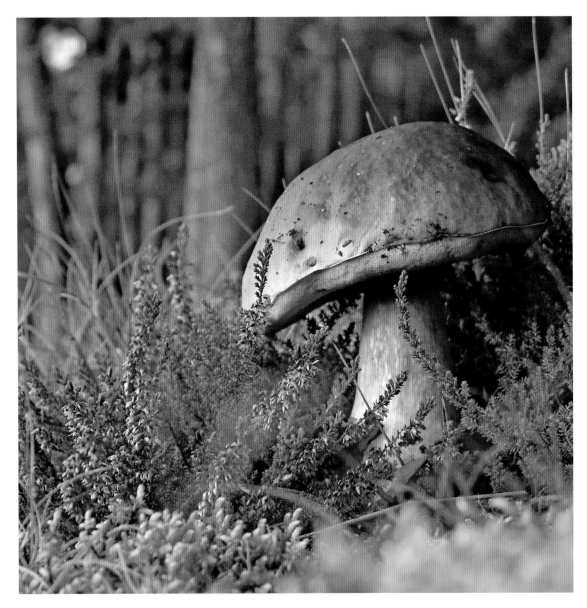

Large trees likely help out younger ones by sending nutrients through a web of fungus living under the forest floor. Fungal networks can also distribute warning messages about harmful disease or invading aphids.

Called mycelium, the fungus shows itself to the world as mushroom caps but lives largely out of sight in a vast underground web.

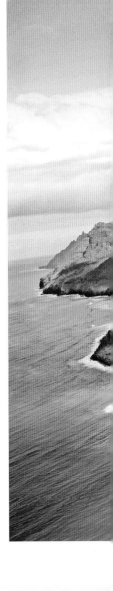

Kauai's Na Pali coast is among the most eroded landscapes in the world. Eons of wind, rain, and ocean waves sculpted its spectacular valleys, cliffs, spires, and caves.

Many of Na Pali's treasures are accessible only by water or on foot.

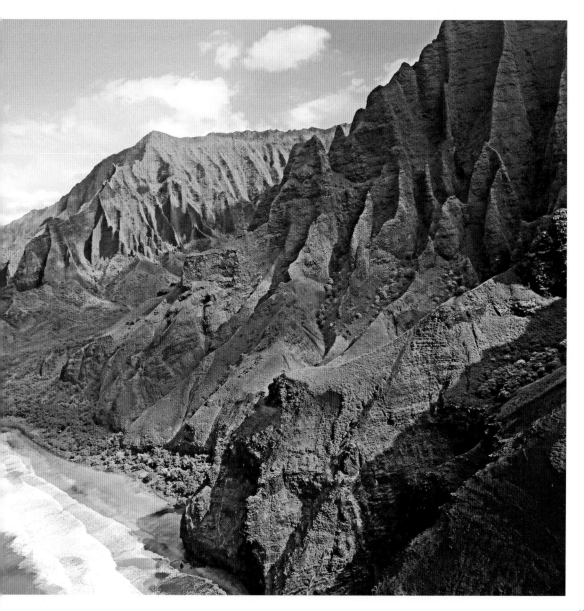

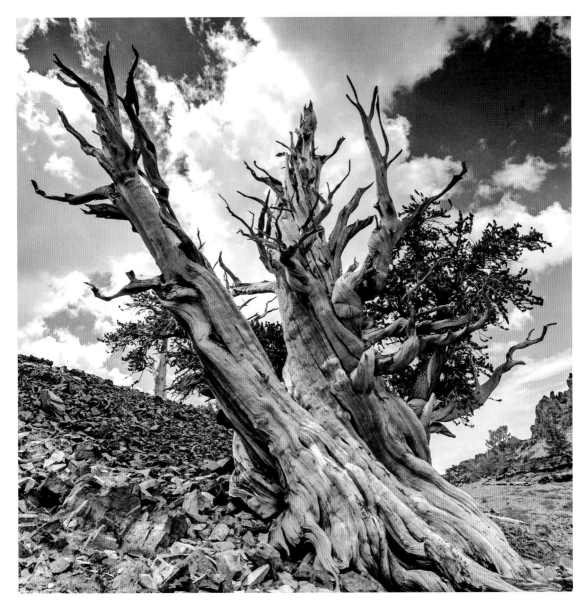

Bristlecone pines are the oldest individual trees on Earth. The most ancient, a 4,848-year-old tree, was already a century old when the first Egyptian pyramids appeared.

The trees grow on wind-whipped mountains in the southwestern United States.

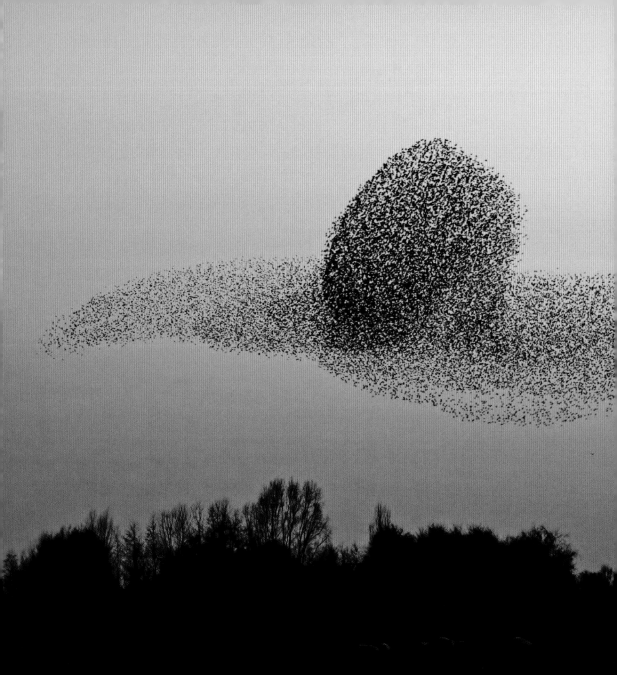

ometimes, thousands of starlings form dazzling, shape-shifting clouds called murmurations. The perfect synchronization of these acrobatic flocks continues to puzzle scientists.

Murmurations often occur at dusk, as the birds look for a spot to roost overnight.

Forgetful squirrels never recover three out of every four acorn seeds they bury for winter storage. The planted seeds grow into oak forests.

In a fruitful year, one oak tree can produce thousands of acorns.

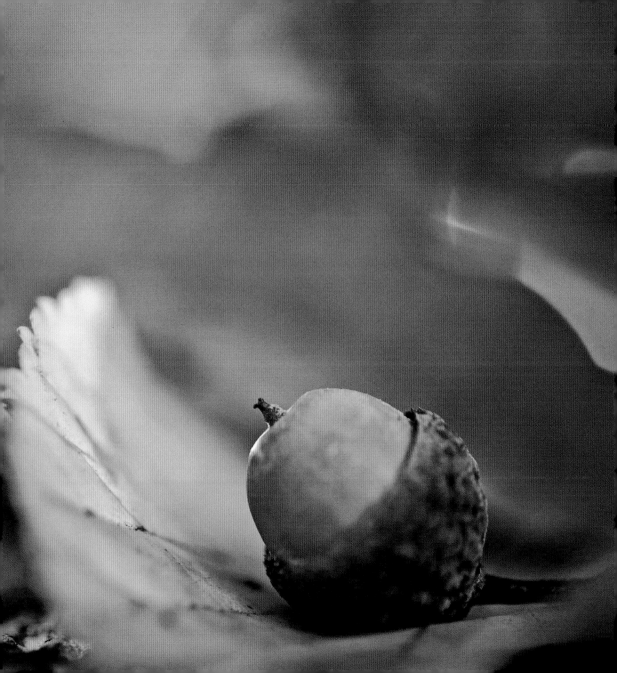

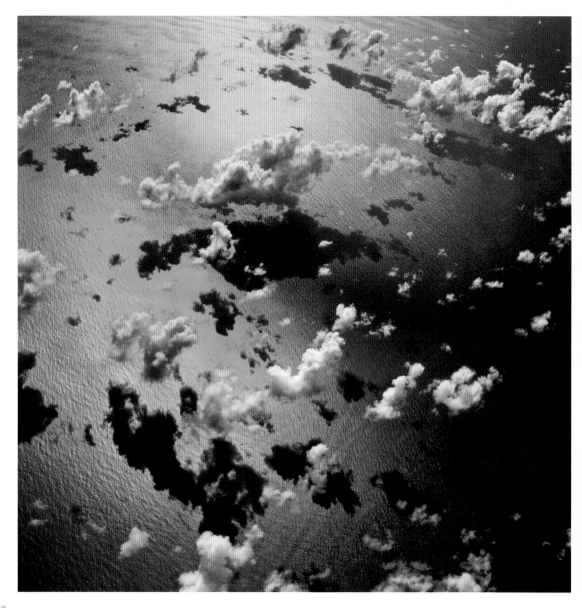

 rainbow looks different to
every person who sees it.
Sunlight reflects off rain droplets at an angle
unique to each viewer.

Large raindrops create bright rainbows with sharp colors; small drops make faded colors.

Birth of the moon

The moon is Earth's constant companion, loyally trailing
its larger neighbor on their journey through space. But this was not
always the case. The moon formed when a Mars-size planet plowed into
the early Earth. Over millions of years, debris kicked up by the collision cooled
and coalesced into the tranquil sphere we see today. The two worlds are
closely connected. From well over 200,000 miles (322,000 km) away, the
moon's gravitational pull causes the rise and fall of ocean tides on Earth.
And scientists now believe that Earth's gravitational tugs contribute to
the formation of long faults and cliffs on the moon's dry crust.

The rising full moon sometimes appears to be enormously overgrown, but this is just an optical illusion.

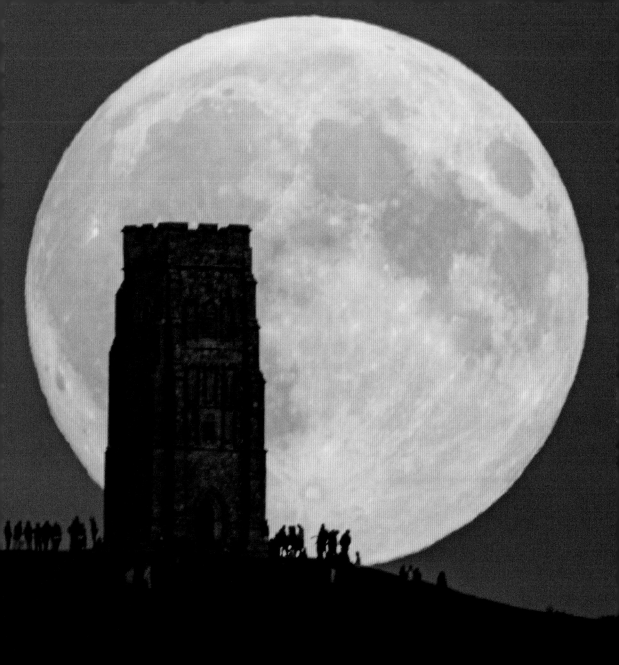

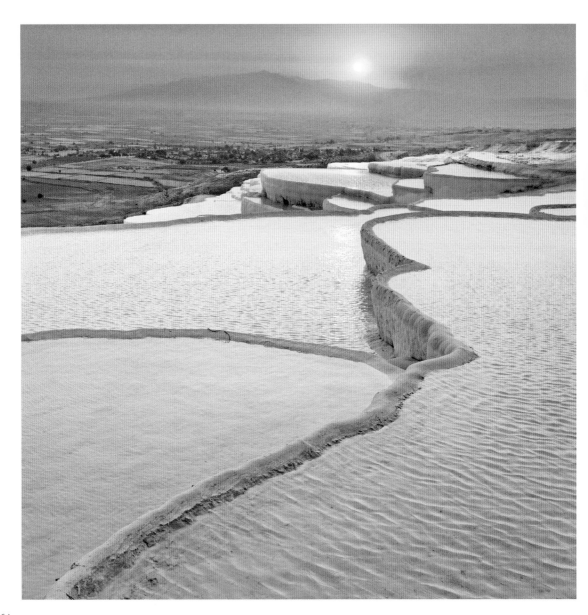

Powered by hot springs, Turkey's travertine pools have been sculpted over time by hot, flowing mineral water. The milky blue pools are a favorite tourist destination.

For thousands of years, people have bathed in these pools; the ancient Greeks even built a spa town nearby.

Looking like big rock candy mountains, China's Zhangye Danxia formations are made from layers of sandstone that have been laid down, one by one, over millions of years.

The geological forces that thrust this bewildering array of colors upward are also responsible for forming part of the Himalayan mountain range.

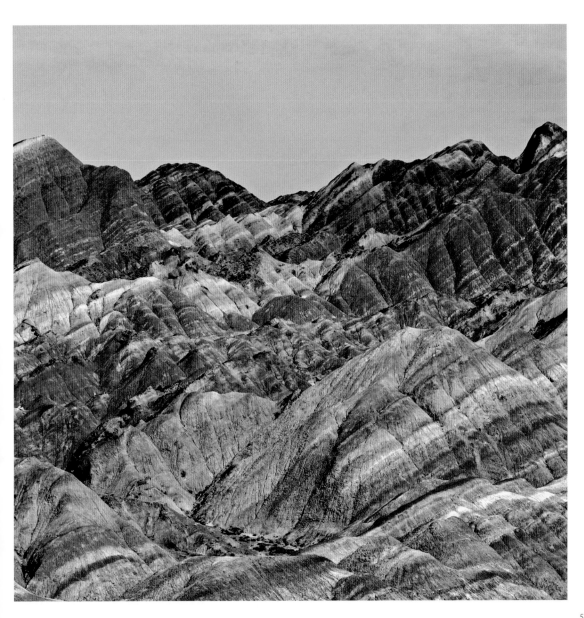

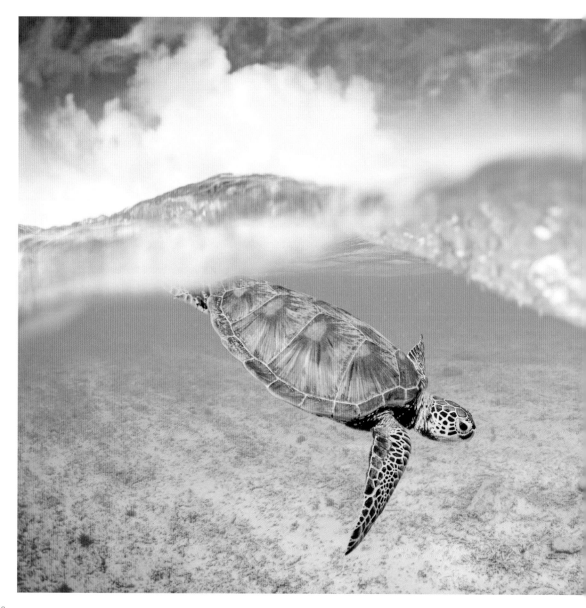

Despite having few landmarks available for navigation, loggerhead sea turtles complete vast, thousand-mile migrations. They are guided by the Earth's magnetic field.

Female loggerhead turtles don't begin reproducing until they're about 35 years old.

Lightning flashes more than three million times each day. Different-colored lightning bolts—purple, blue, pink, green—are caused by light traveling through atmospheric hazes, raindrops, or dust.

A lightning bolt heats surrounding air to at least 18,000 degrees Fahrenheit (10,000°C).

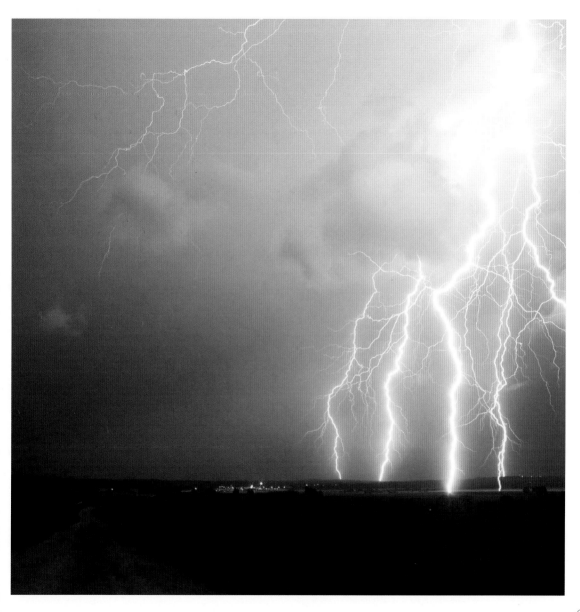

R ather than buds, spring in the
North Atlantic Ocean bursts
with phytoplankton blooms. By reproducing
rapidly, they create aqua-hued swirls
visible from space.

*Phytoplankton are microscopic marine organisms that use sunlight photosynthesis
to grow, removing carbon dioxide and releasing oxygen just like trees.*

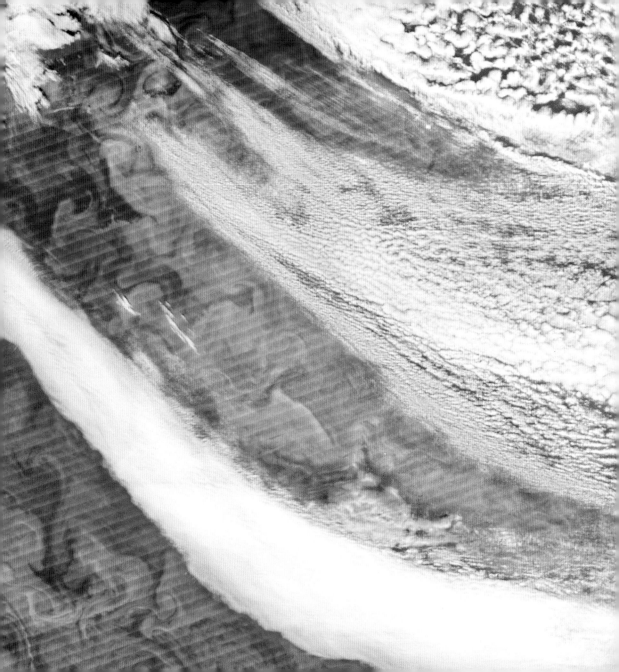

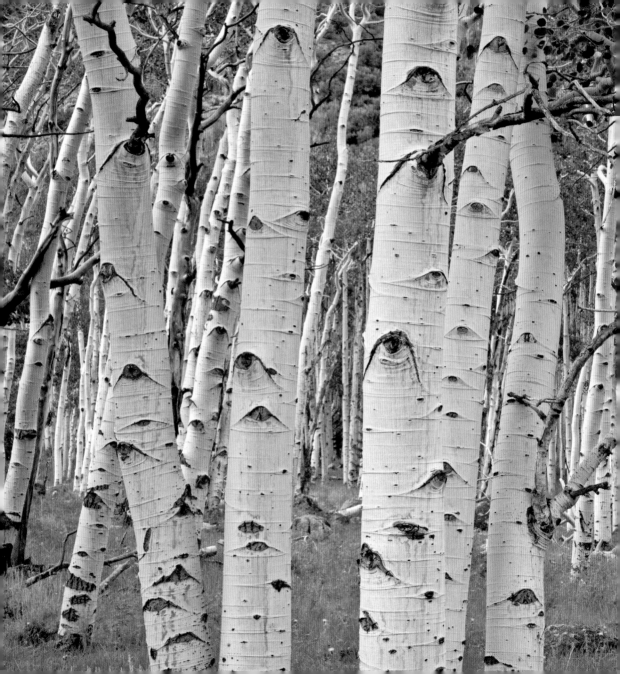

In Utah, a grove of quaking aspen
shares more than appearance:
The genetically identical trees have
a single root system and form a massive
organism that spans 107 acres (43 ha).

The quaking aspen is named for its delicate leaves, which flutter in the gentlest breeze.

Hummingbirds

Though tiny—the smallest weighs less than a dime—hummingbirds are the unequivocal acrobats of the bird world and zoom around like shimmering, sugar-loving helicopters. With wings that flutter as fast as 80 times each second, hummingbirds are able to fly forward, backward, sideways, and even upside down. They're also extremely feisty and territorial, and will chase not only other hummingbirds from their flower patches, but also birds as large as hawks and crows. Hummingbirds are also prolific eaters: To maintain their energetic lifestyle, the birds guzzle more than their weight in nectar each day.

Some of these tiny tyrants fly hundreds—or even thousands—of miles during their annual migrations.

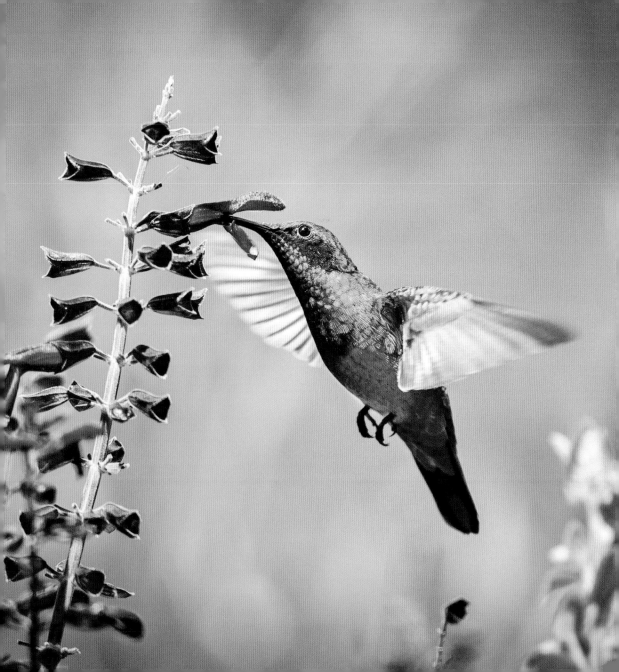

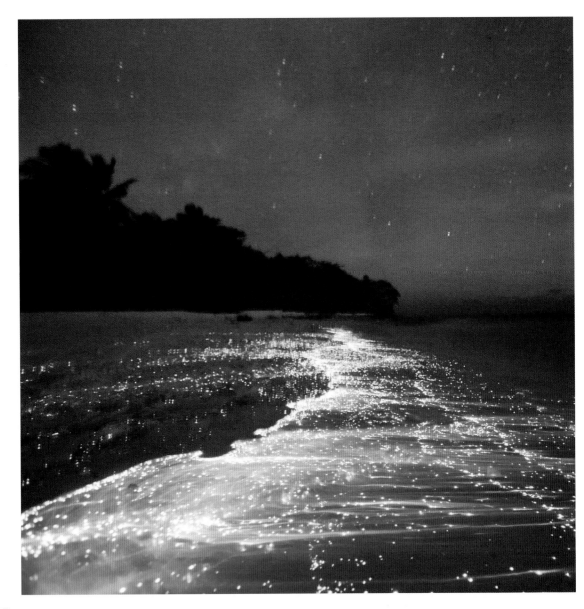

Gleaming blue tides and incandescent waters aren't a trick of photography. They're the work of billions of tiny, glowing organisms called dinoflagellates.

Fireflies, many marine creatures, and even some fungi are bioluminescent, meaning they produce light.

he fiery brilliance of opals comes
from layers of tiny, precisely
ordered spheres that help scatter incoming
light, producing a rainbow of color.
Blue glimmers are the most common;
red are the rarest.

A fire opal was discovered in a meteorite from Mars that crash-landed on Earth in 1911.
It supports scientists' theory that microbial life once existed on the red planet.

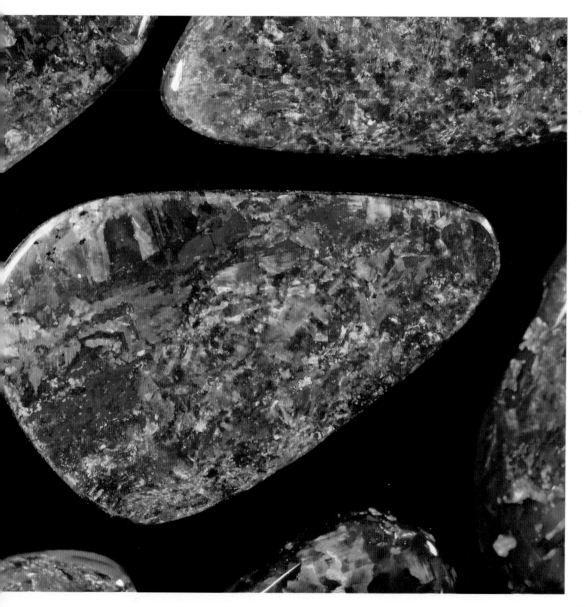

very so often, a ghostly green glow colors the disappearing disk of the setting sun. Called a "green flash," the peculiar phenomenon is the result of atmospheric light scattering.

The green flash can also be seen at sunrise.

*L*otus plant leaves are among the planet's most water-repellent surfaces. Nanobumps on the surface prevent water from being absorbed, so it balls up and rolls off.

The leaves are also incredibly good at keeping themselves free of dirt and germs.

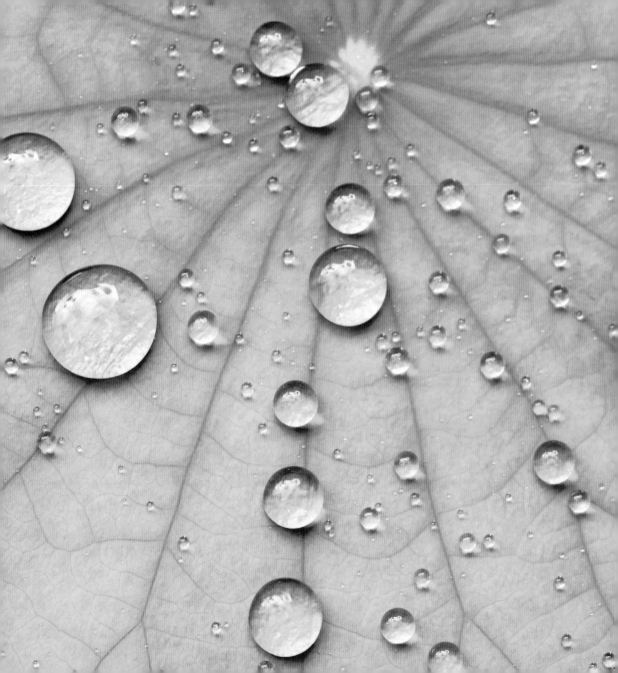

The star-studded shapes in our nighttime skies are slowly drifting. In several millennia, Polaris will no longer be the North Star—Gamma Cephei will.

The stars composing our constellations are also moving,
and in 75,000 years, the skies will be nearly unrecognizable.

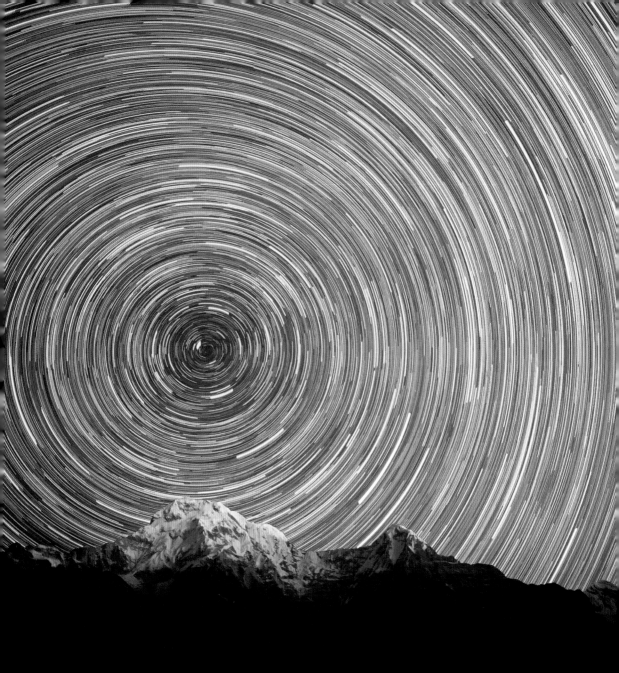

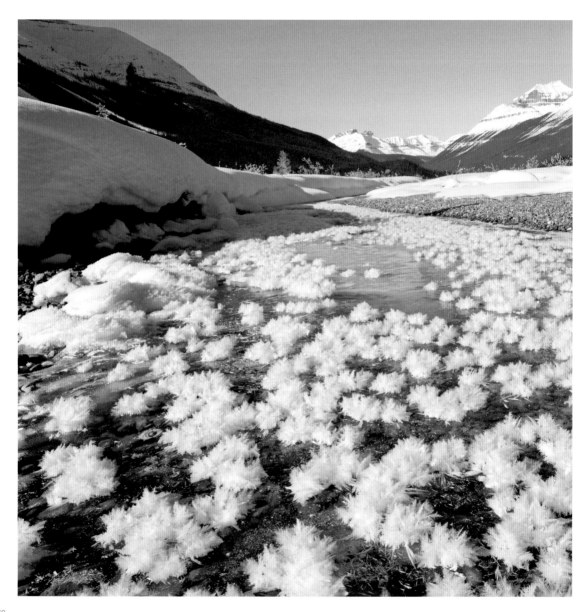

ometimes, the morning sun illuminates a calm, freezing sea that appears to be in bloom. These delicate sculptures, called frost flowers, are made from shards of ice.

Frost flowers are loaded with salt and microbes.

Masters of camouflage

Chameleons often claim the title of masters of disguise,

but cuttlefish, a type of sea creature, are the true kings

of camouflage. Cuttlefish can blend in with just about any background,

natural or artificial, courtesy of multiple specialized layers of skin. One of

these contains pigment-filled sacs that can expand and contract, producing

radical changes in skin color and pattern. In addition to their camo colors,

cuttlefish can also change the texture of their skin, and will sometimes

rearrange their eight legs so they better resemble tufts of seaweed or rocks.

Cuttlefish have blue-green blood, which is pumped through their bodies by three hearts.

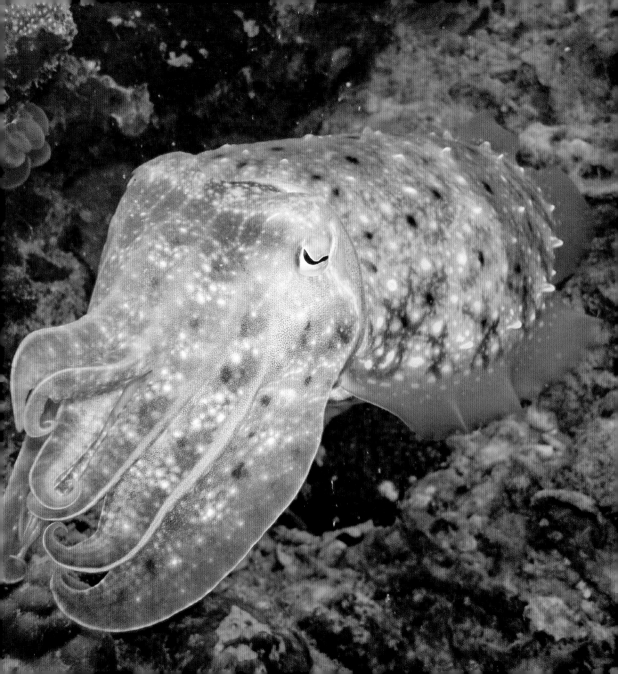

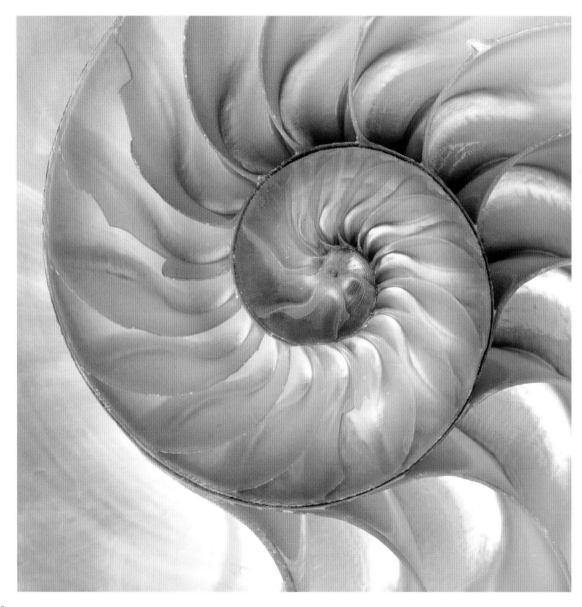

Hiding in the spiral of a nautilus shell is a fundamental mathematical mean called the golden ratio, which is reflected in its precise nesting pattern.

The golden ratio can be found in flower petals, pinecones, galaxies, and the Egyptian pyramids.

he neon blue rivers of fire streaming out of Indonesia's Kawah Ijen volcano bear the illusion of lava but are actually caused by the combustion of sulfuric gases and liquid sulfur, which burn blue.

The blue flames can be as much as 16 feet (5 m) tall.

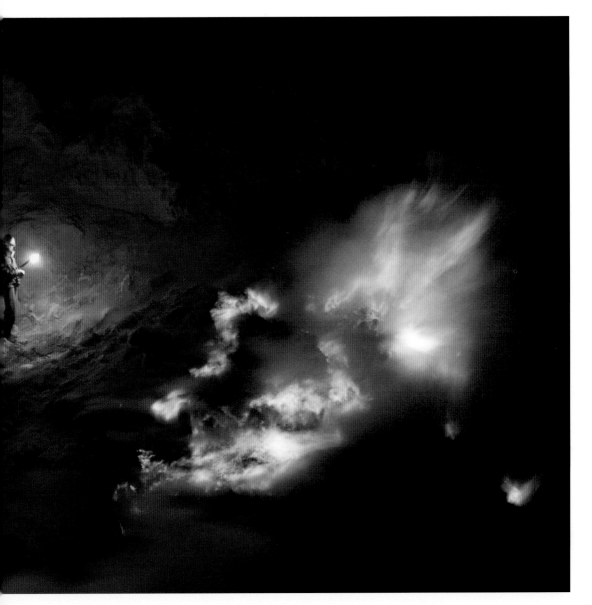

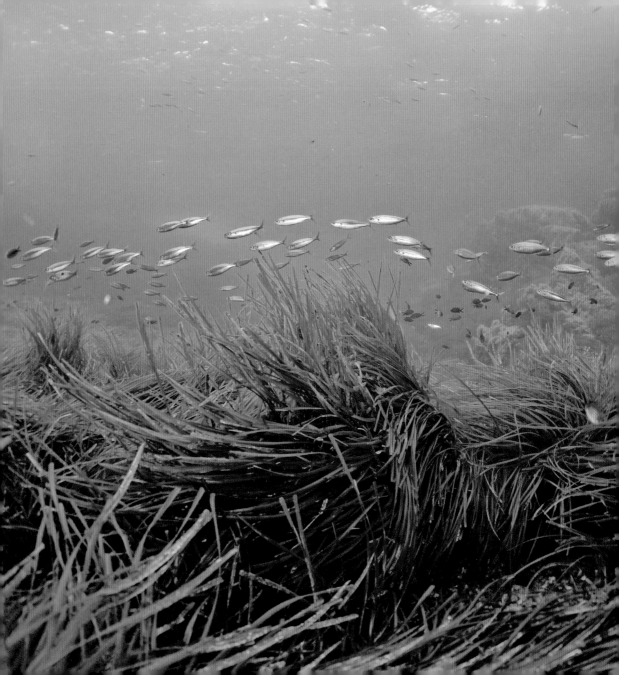

A lush underwater meadow of sea grass growing off the coast of Spain is more than 100,000 years old, perhaps taking root at the dawn of humanity.

Sea grass, Posidonia oceanica, *is named after Poseidon, the Greek god of the sea.*

ulips continue to grow after being cut, resulting in a "tulip dance" where each flower in the vase gently tilts its petals toward the sun.

In Victorian times, flowers were assigned special meaning. Tulips symbolized passion.

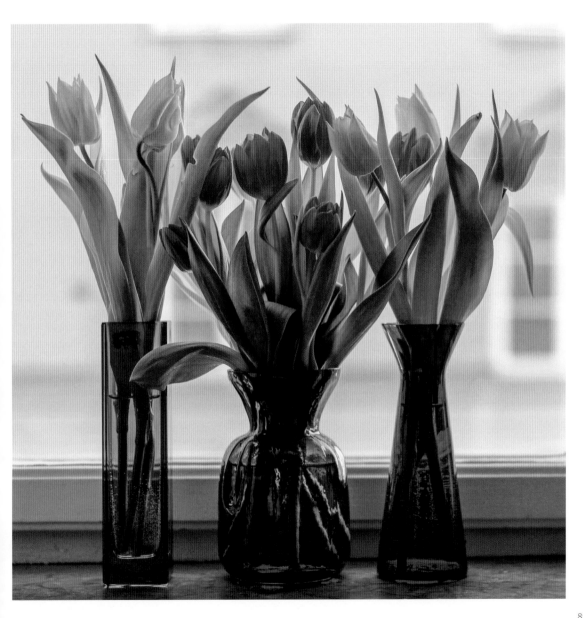

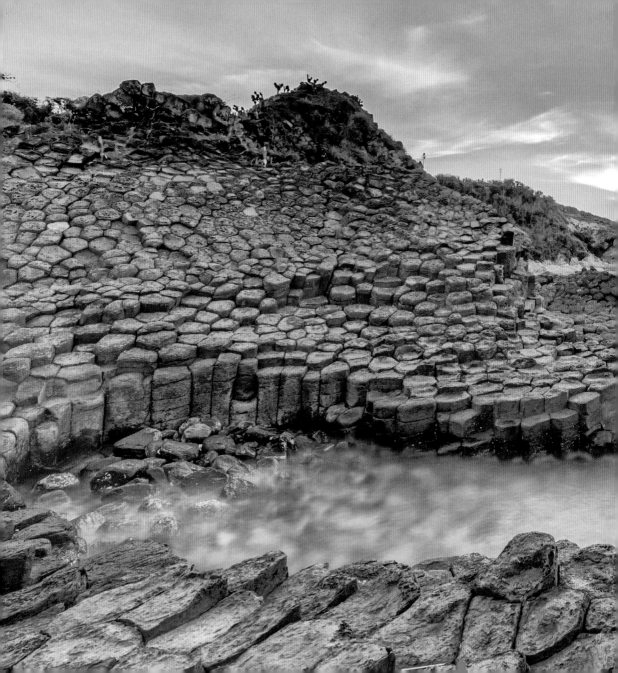

The weird natural geometry of Giant's Causeway, in Northern Ireland, is not the footwork of giants. Rather, the 40,000 basalt columns grew from an ancient volcanic eruption.

According to Irish folk stories, the giant Finn MacCool crossed the causeway to fight his Scottish rival. The same rock formations are seen on an island in Northern Scotland.

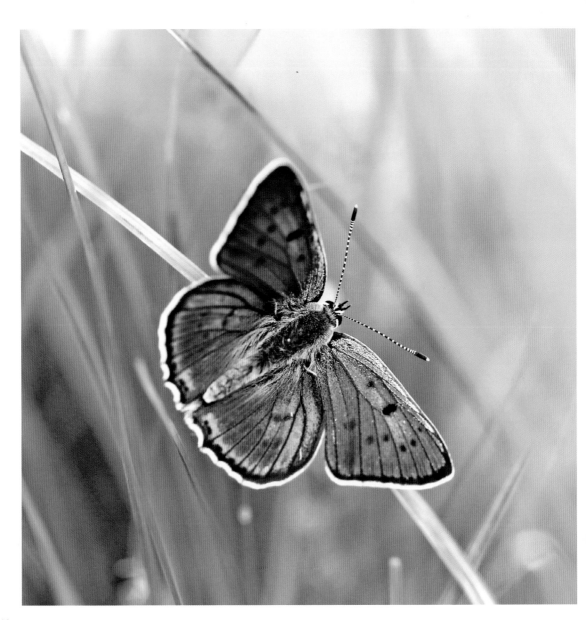

utterflies must warm their wings
in the sun before flying. This behavior
is called "basking" and helps ready
their muscles for flight.

A group of butterflies is sometimes called a flutter.

Rainbow eucalyptus

A fast-growing, evergreen eucalyptus tree from the South Pacific has a unique and extraordinary gift. During the "shedding" season its outer layer of bark peels back to reveal stunning streaks of multicolored inner bark. The colors range from burnt orange and lime green to salmon pink, teal, and purple-blue. Nicknamed the rainbow eucalyptus, *Eucalyptus deglupta* is native to the rainy and humid tropical forests of New Guinea, New Britain, Indonesia, and the Philippine Islands. It is favored for decorative gardens but can also be found growing in the wild. The multihued forests have been called botanical kaleidoscopes for their ephemeral displays.

The rainbow eucalyptus tree grows up to 250 feet (76 m) tall in its native environment.

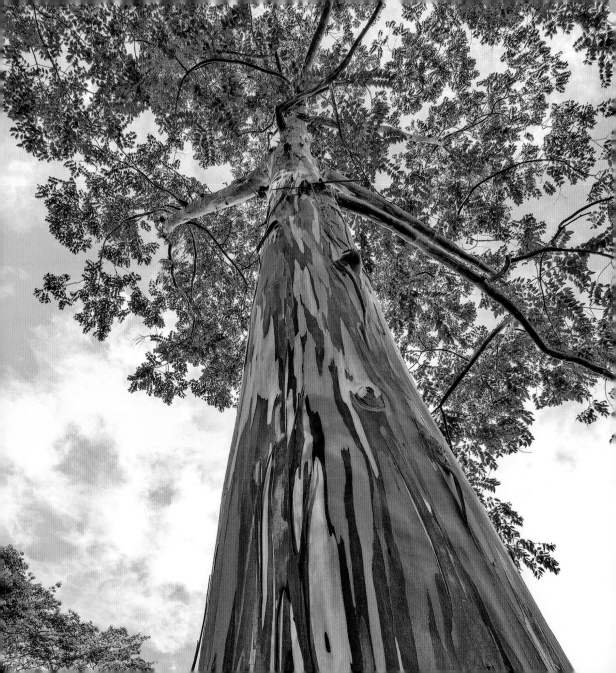

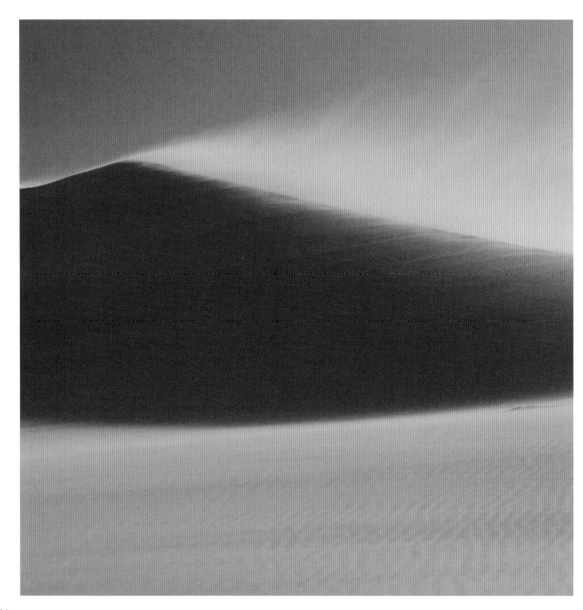

Appearing to wake from quiet slumber, sand dunes around the world sometimes burst into song, producing sounds that have been described as booming, rumbling, barking, or squeaking.

Scientists aren't entirely sure why some sand dunes sing, but they suspect the dune song is triggered by wind or the reverberation of grains of sand sliding over one another.

In a saltwater lake in the South Pacific, millions of golden jellyfish follow the sun's arc across the sky every day, completing a looping, perpetual migration.

The sting of these golden jellies isn't powerful enough to be harmful to humans, but it may be a bit uncomfortable.

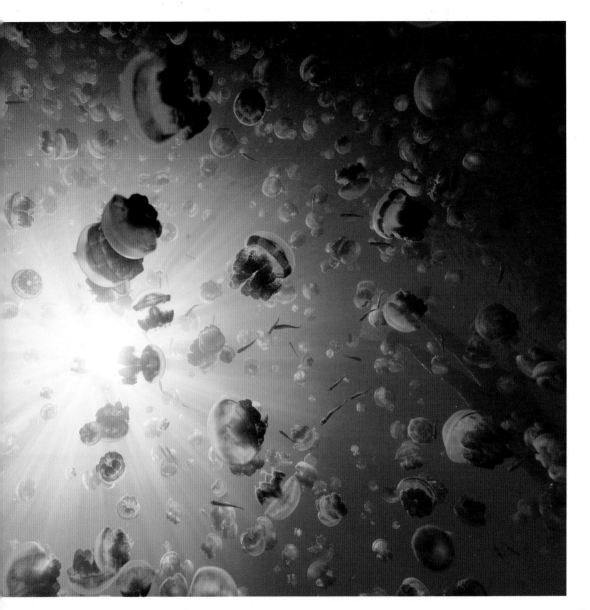

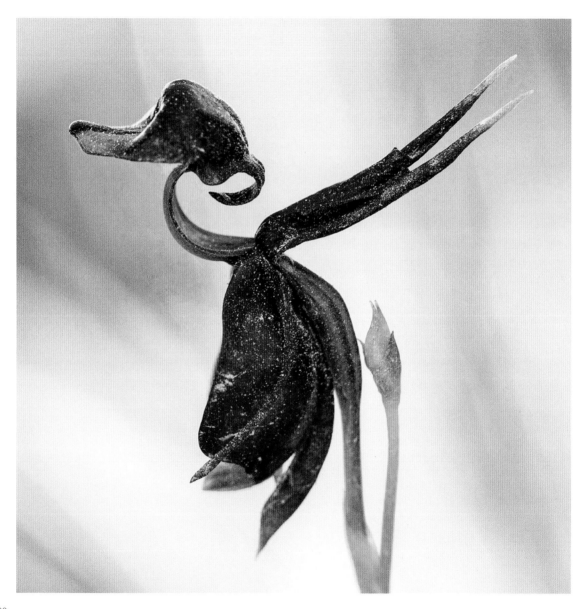

In Australia, an orchid that blooms in spring looks exactly like its name suggests. Called the flying duck orchid, the flower's shape is just an accident of evolution.

The orchid is pollinated by insects and is often found among eucalyptus groves.

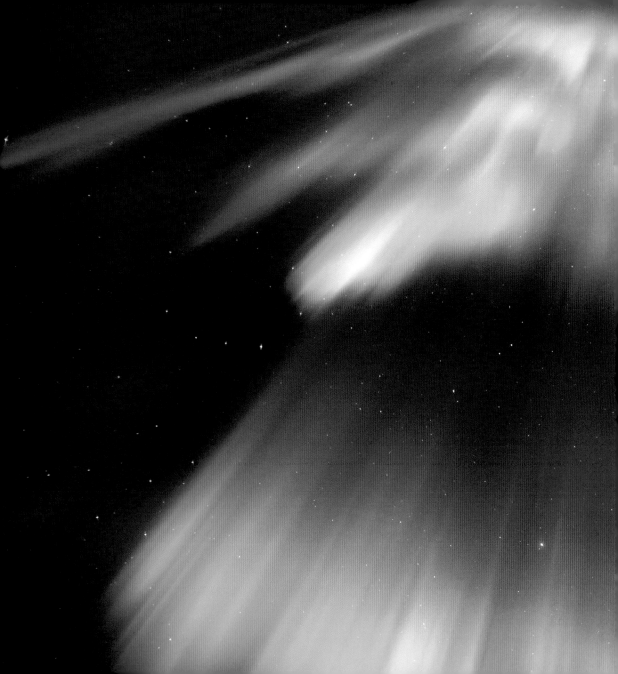

The brilliant evening auroras that swirl above Earth's Poles get their colors from different molecules in the atmosphere. Charged particles unleashed by the sun collide with these molecules, producing the dazzling light show.

Auroras also come in many shapes, including arcs, curtains, spirals, and a simple diffuse glow.

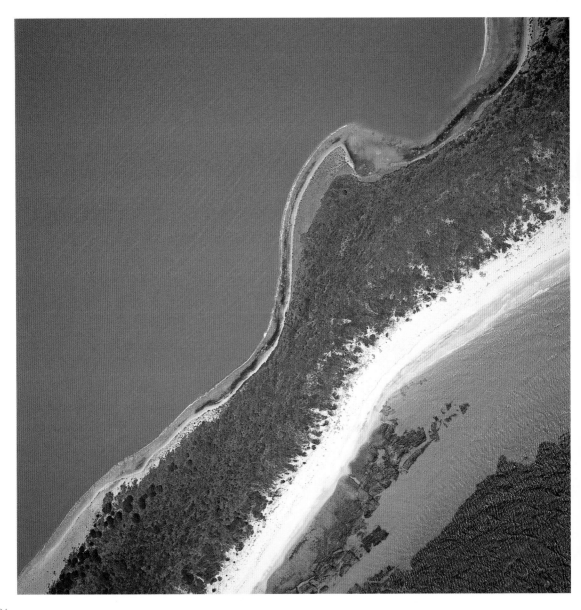

hat looks like a pool of bubble gum is really western Australia's Lake Hillier. The supersalty water is stained pink by pigmented algae.

You can safely swim in Lake Hillier, which wasn't discovered until 1802.

If you're a dog, the nose definitely knows. A dog's sense of smell can be 10,000 times more sensitive than a human's—they live in a completely different odoriferous world than we do.

A dog's nose has about 300 million olfactory receptors. Humans have roughly 6 million.

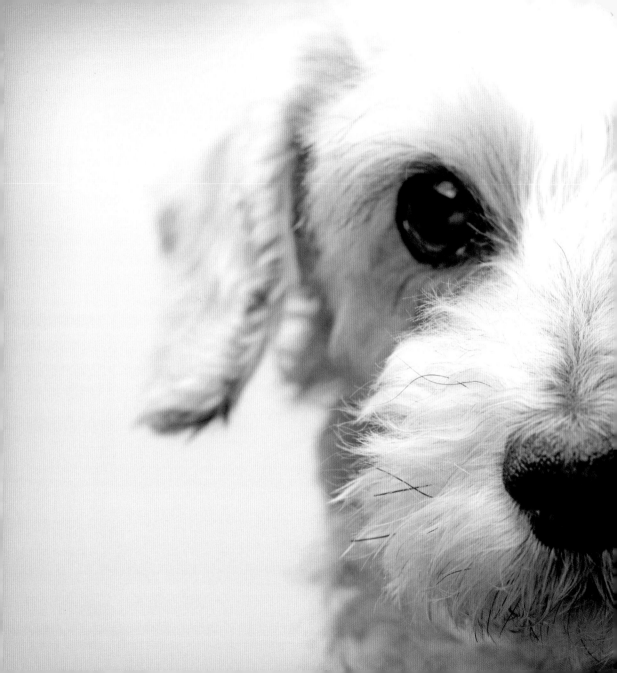

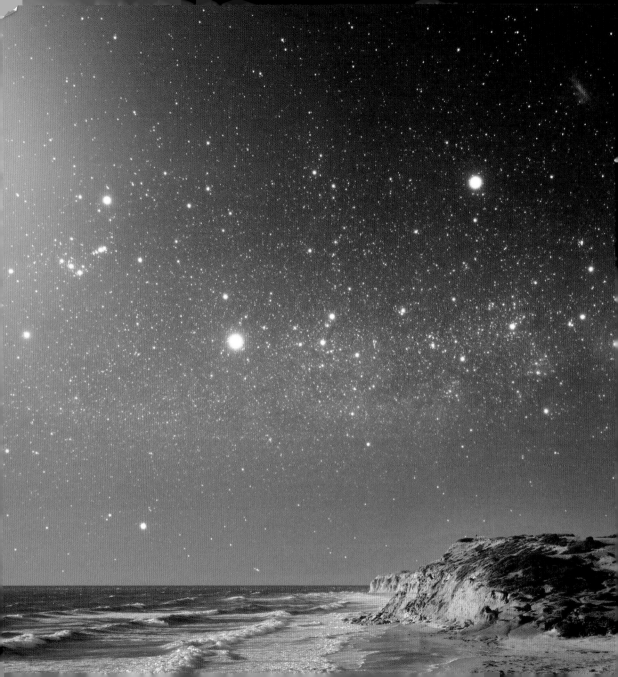

he stars in the visible universe outnumber all the grains of sand from every beach on Earth.

One cubic centimeter of sand holds about 8,000 grains.

Long-distance calls

Elephants "hear" over long distances by sensing the vibrations
of sounds traveling through the ground. It's a somewhat unusual sixth sense
among mammals, being more commonly found in insects and spiders.
But some elephant calls contain extremely low-frequency rumbling sounds
that are capable of shaking the ground. Scientists think elephants detect these
vibrations using a combination of sensory structures and wiggling bones in
their nose and toes. And although it's hard to say precisely how far away
elephants could be and still have a conversation, estimates
are on the order of at least 10 miles (16 km).

Elephants travel in family groups and, like humans, grieve over the death of their kin.

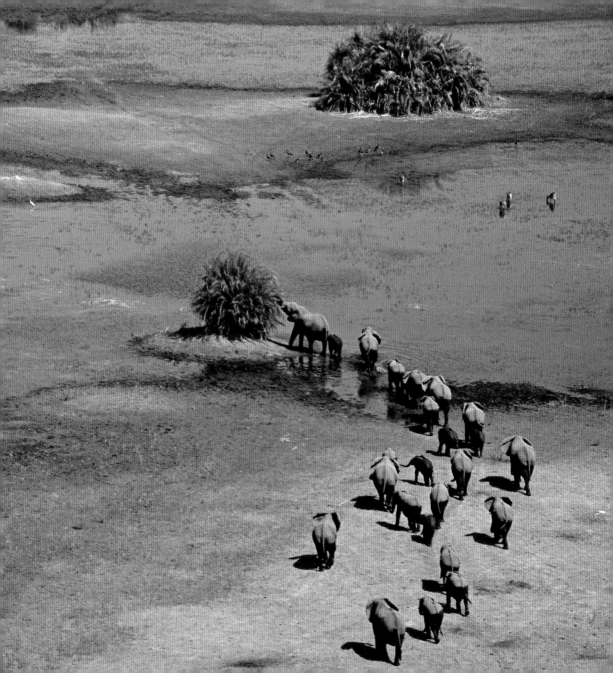

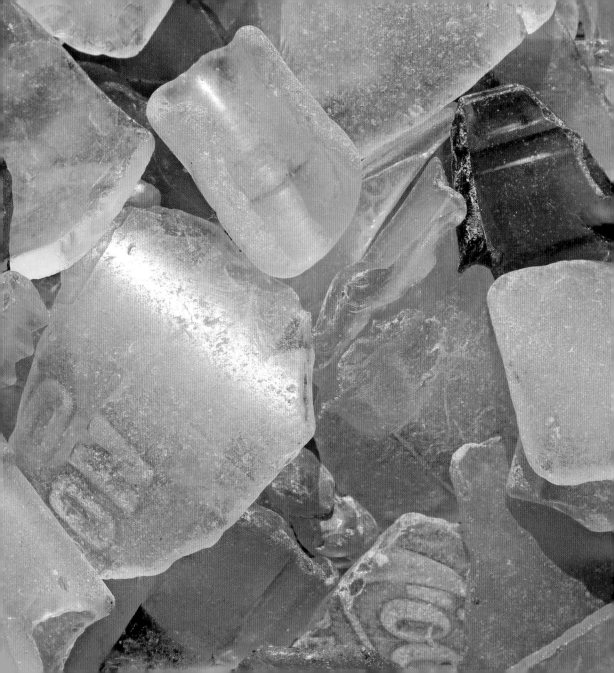

ver decades, shards from broken bottles, pottery, and sometimes shipwrecks are transformed into smooth, frosted sea glass.

Folklore tells us that sea glass is actually mermaid tears.

he songsters of the sea, male humpback whales belt out tunes that last for hours and travel for dozens of miles underwater.

The mysterious songs were originally believed to play a role in mating, but they may serve other purposes.

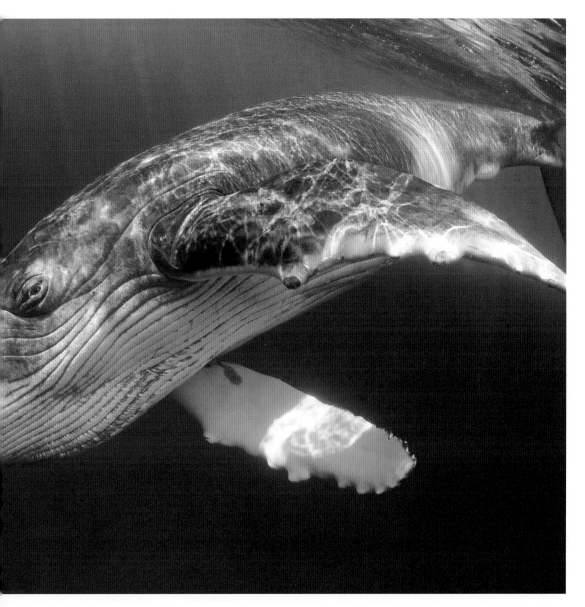

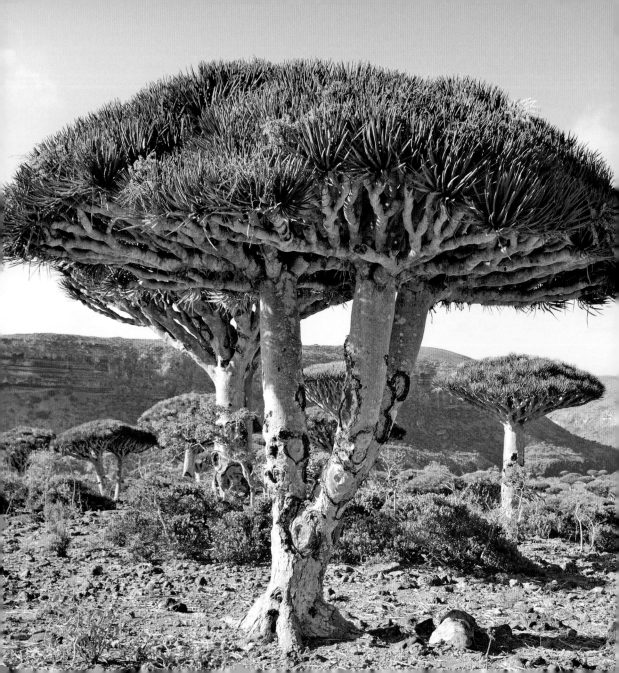

ocotra Island, in the Indian Ocean, is one of the strangest-looking places on Earth. Roughly one-third of its plant and animal species are not found anywhere else in the world.

The unusual dragon's blood tree, Dracaena cinnabari, *is named after its bright red sap.*

When the sun shines through ice crystals from wispy cirrus clouds at a particular angle, its rays create an iridescent halo. The refracted light is called a circumhorizontal arc, or colloquially, "fire rainbows."

The hexagonal ice crystals in the cloud refract, or bend, sunlight in the same way that light passes through a prism.

Flamingos are pink because of a pigment
in the brine shrimps and algae they eat.
They will change color if they go on
a different diet.

The birds are highly social, and a single colony can have tens of thousands of flamingos.

At Bolivia's Salar de Uyuni, a thin layer of water can turn the world's largest salt flat into the world's largest mirror, and blur the boundaries between heaven and Earth.

The salt flat covers more than 4,000 square miles (10,360 sq km).

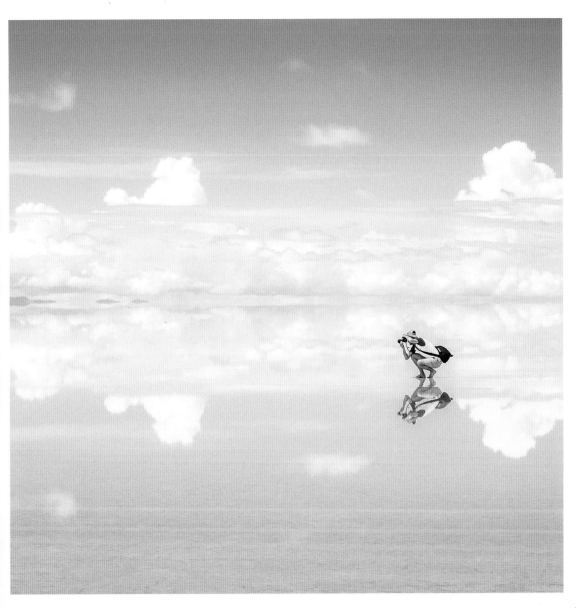

Other books in this series

Little Book of Thanks
Mother's Love
Friends Forever
The World Awaits
Love You, Dad
True Love

Illustrations Credits

*"Give yourself peace of mind.
You deserve to be happy. You deserve delight."*

—Hannah Arendt

Your Road Map to Inner Peace.

Beautifully illustrated with inspiring photographs, this lovely little guide is filled with simple tips to help you unwind and enriching quotes that remind you how to savor life's simple moments.